CAT PAWS

PIE International

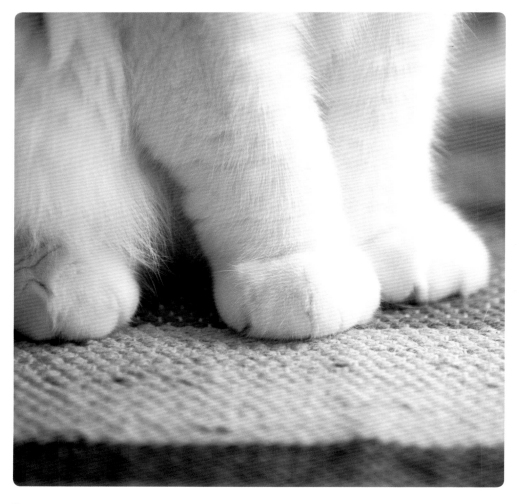

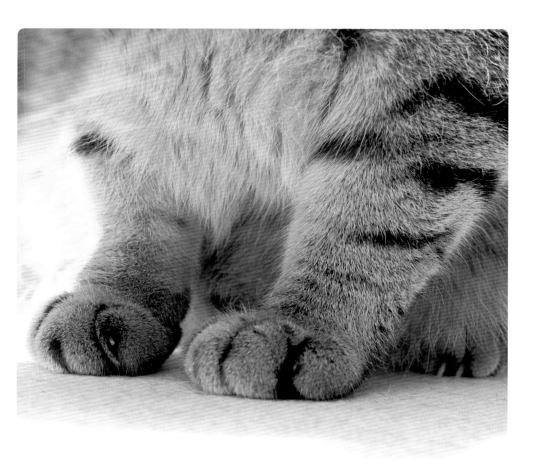

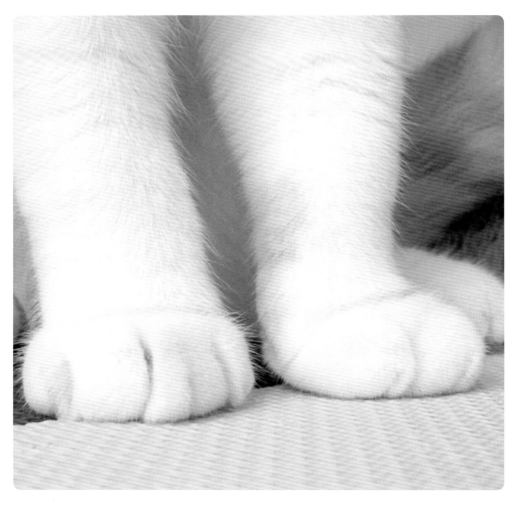

4

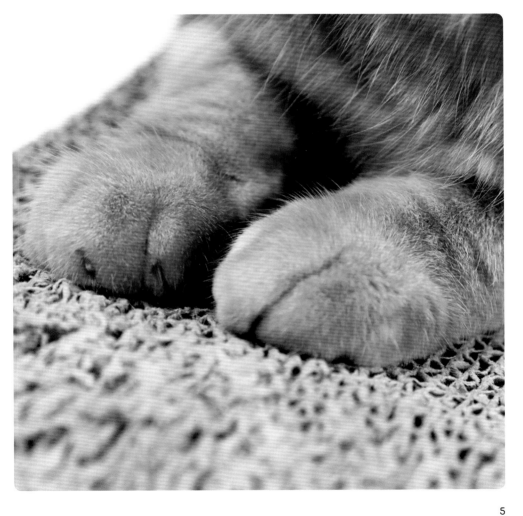

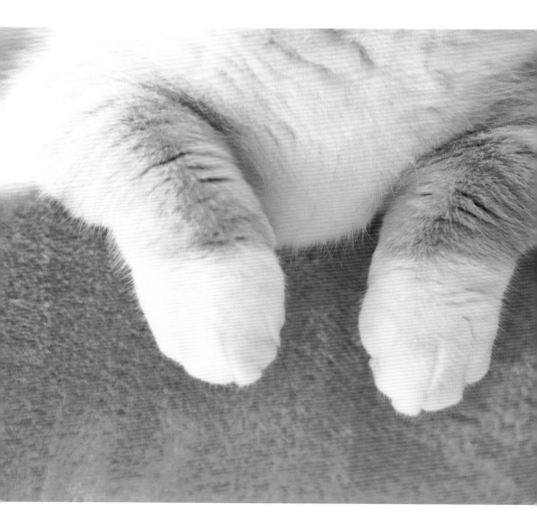

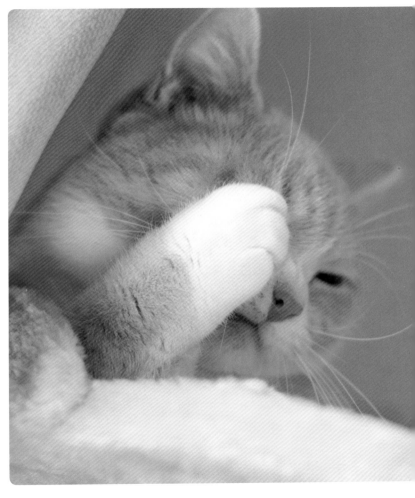

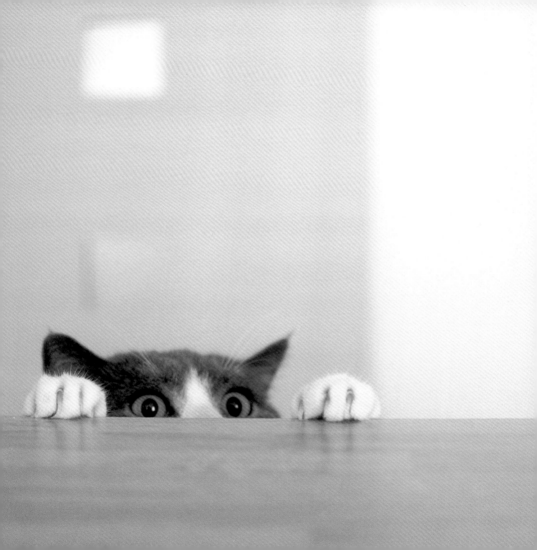

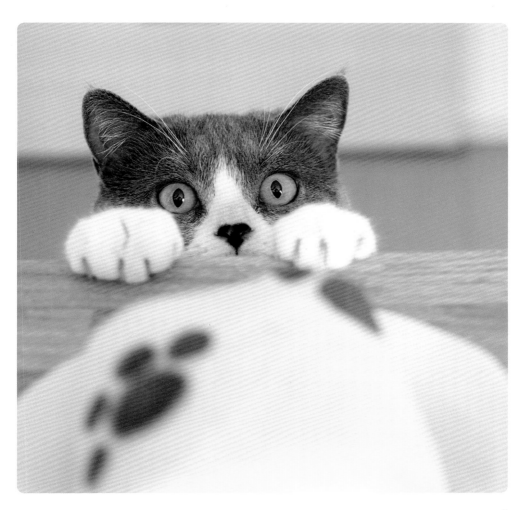

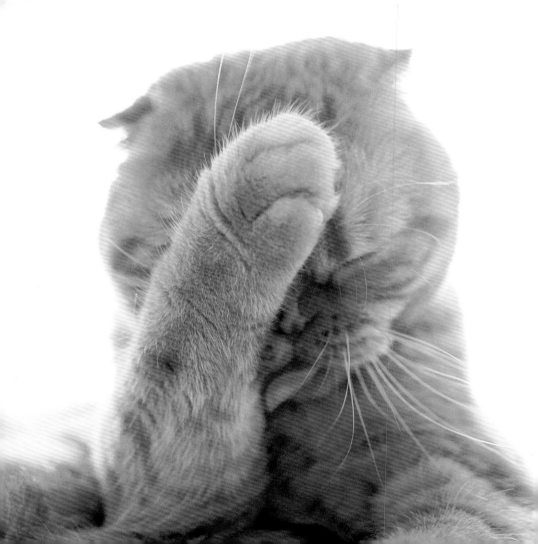

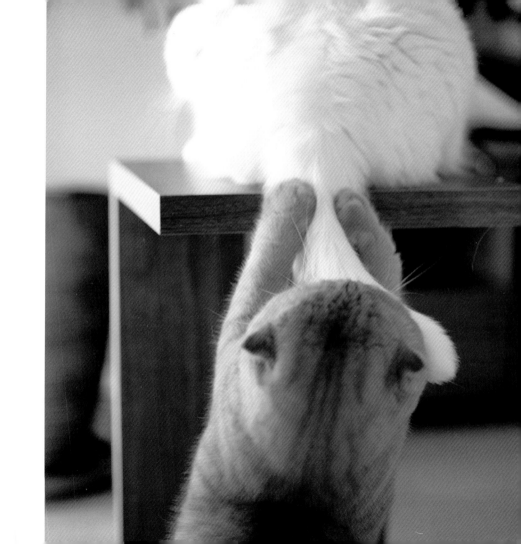

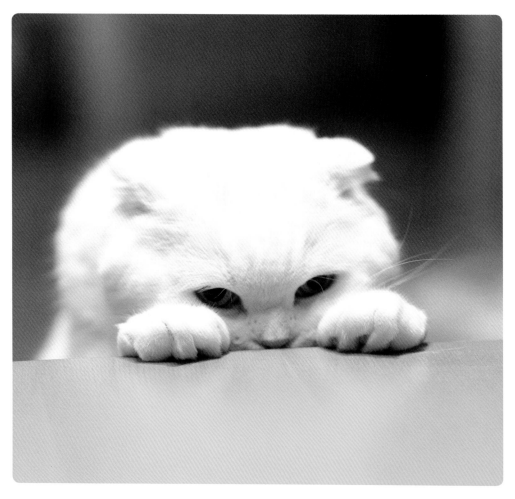

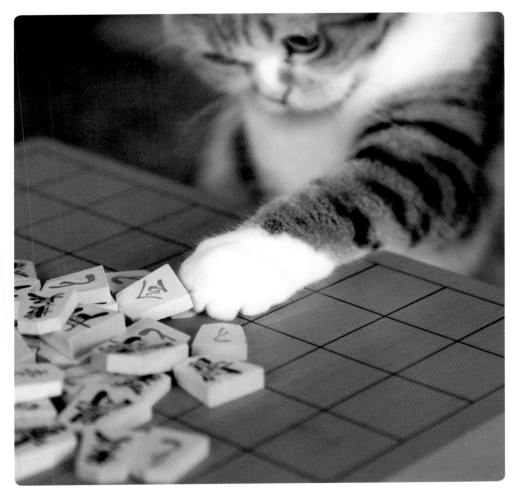

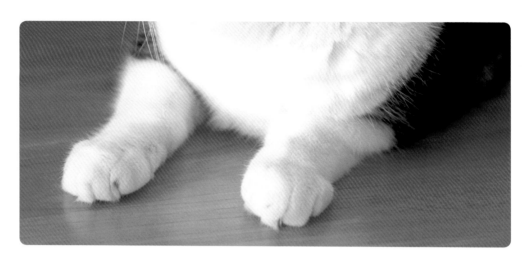

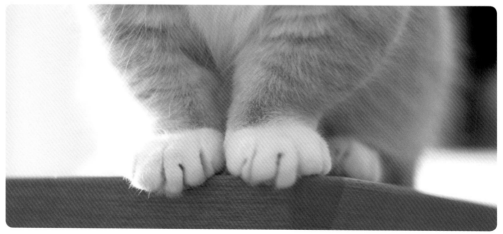

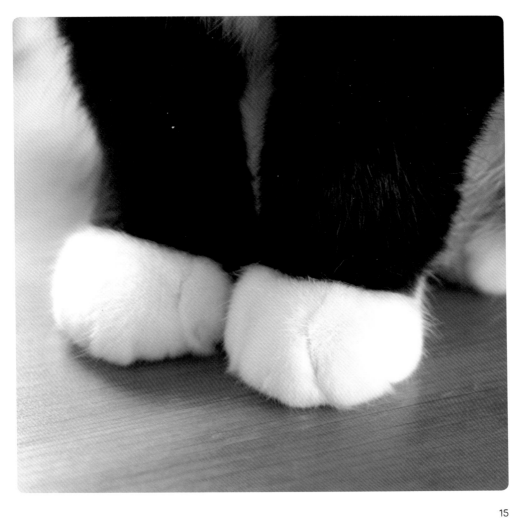

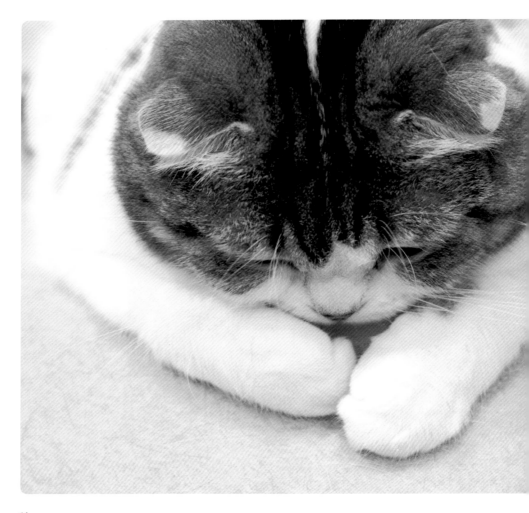

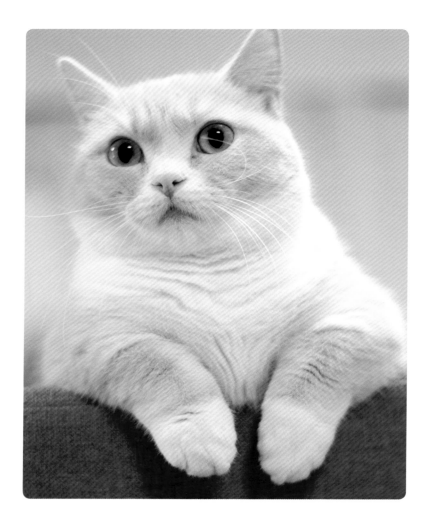

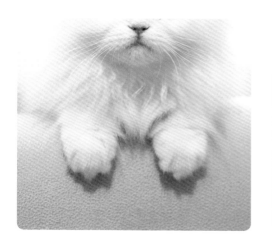

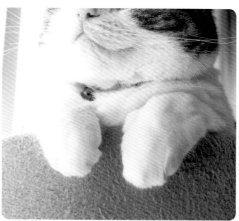

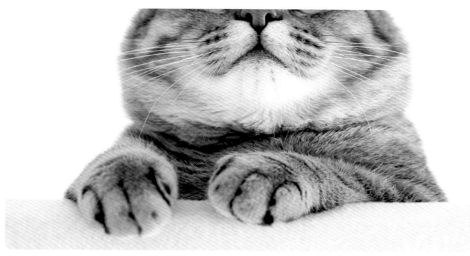

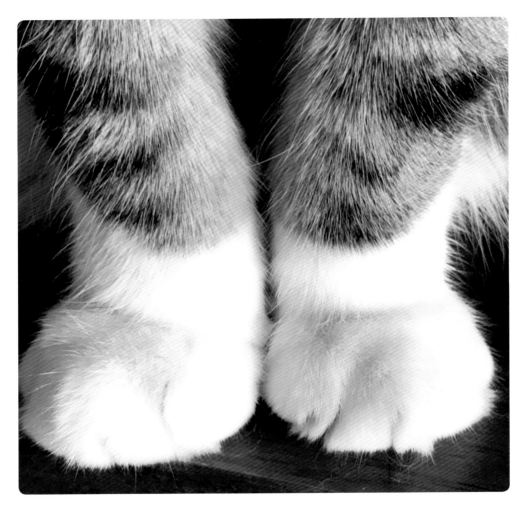

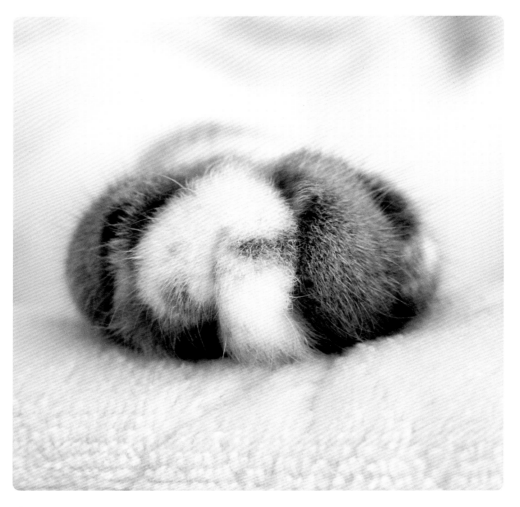

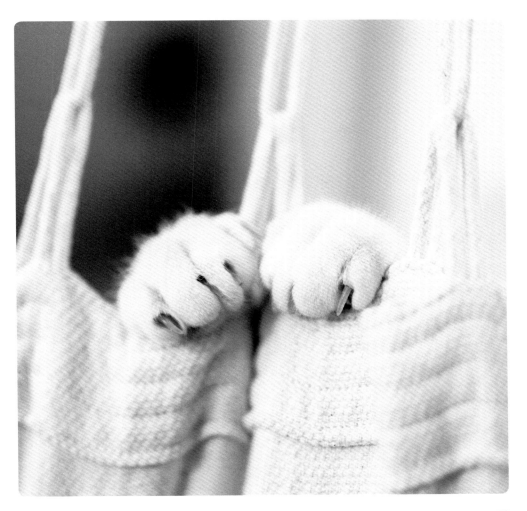

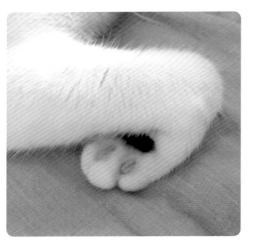

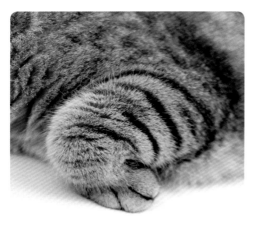
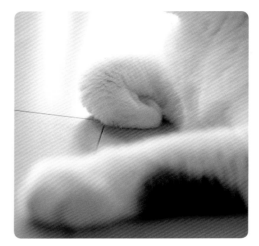

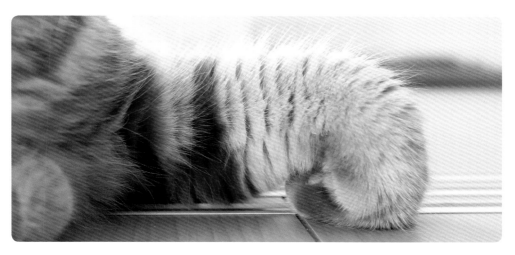

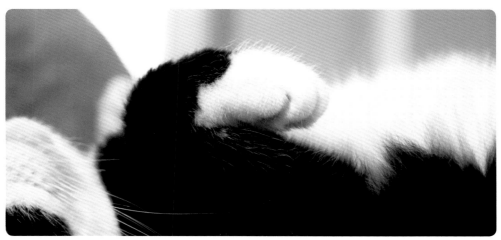

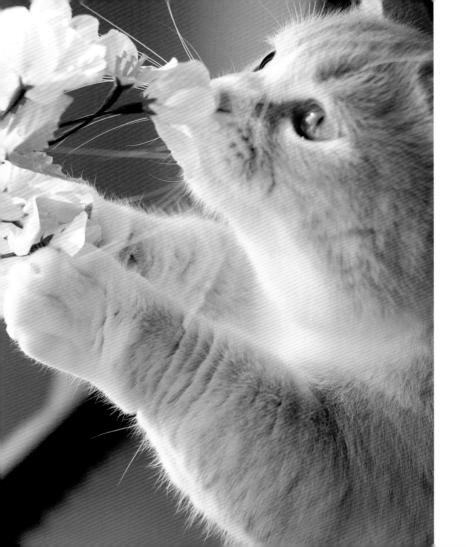

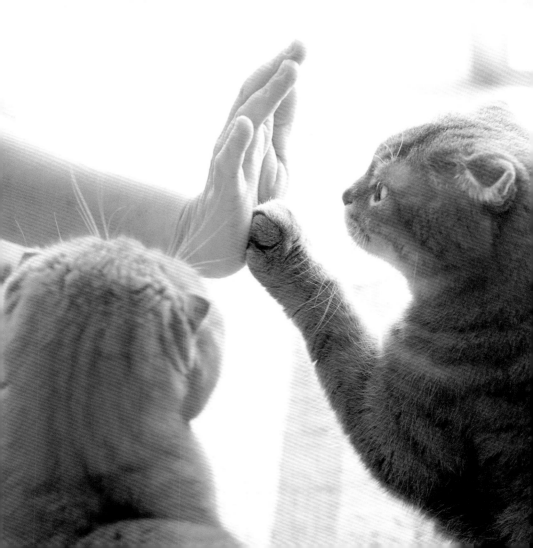

Cat's Paw Trivia ①

From its face, ears, belly and bottom to its tail, everything about the cat's features is adorable. Its rounded paws are overwhelmingly charming, with their fluffy hair and squishy paw pads. Let's look at some lovable points of cats through the following poses.

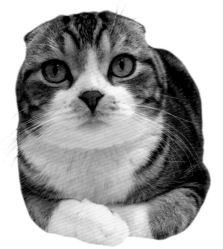

Folding
Cat loaf, showing that the cat is relaxing.

"Cat loaf" is the way cats fold their paws. It is so called because the pose resembles a loaf of bread. The cat loaf shows that the cat is relaxed, because it is hard to abruptly stand up from this position.

Hiding

Tail wrapped around the legs

Cats are usually sensitive to the cold, so use their tails to warm themselves. In winter, you will often see them covering their legs with their tails like we would wear a scarf around our neck.

Grooming

Cats are very tidy. They happily lick their body and paws whenever they can snatch a moment.

For cats, grooming is not just about keeping their bodies clean but works to adjust their body temperature, as a diverting habit or as a communication tool.

Retracting

Claws: in or out?

The cat's claws are its weapons, extending easily from their sheath. They usually hide their claws in the folds between their "fingers," which is the reason why cats can quietly tiptoe.

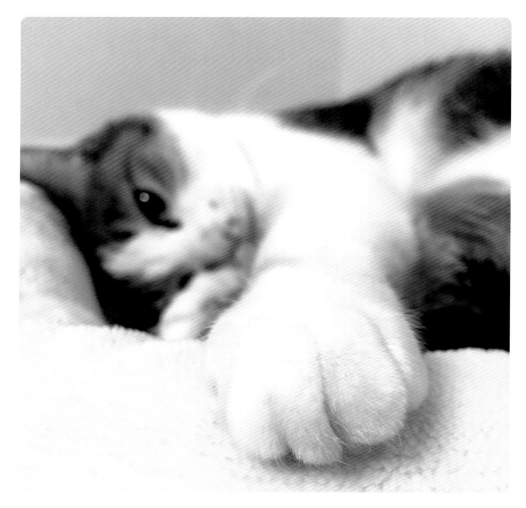

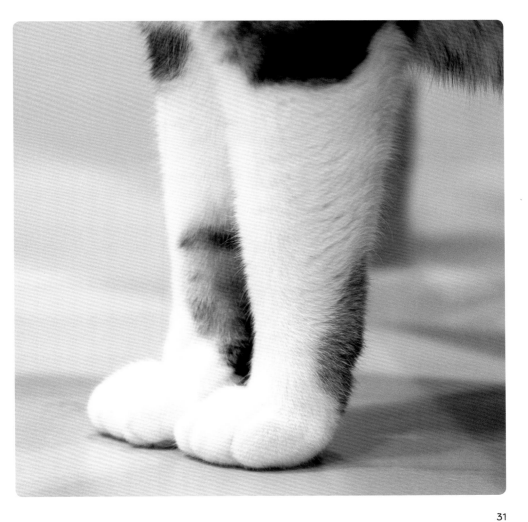

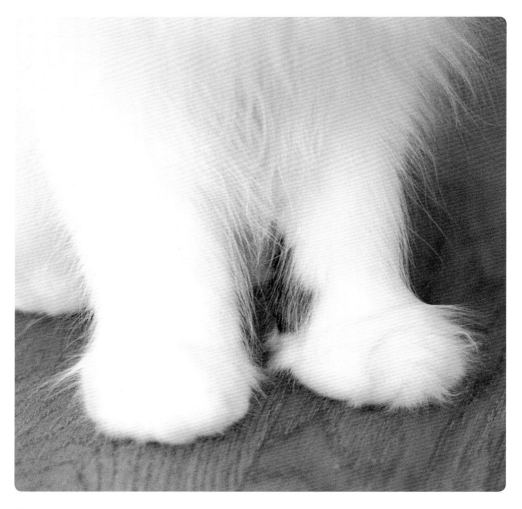

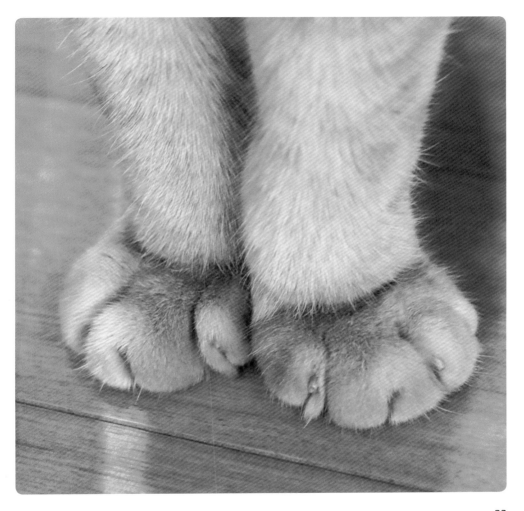

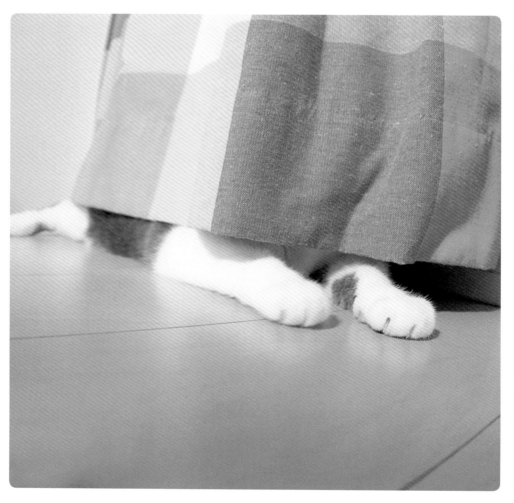

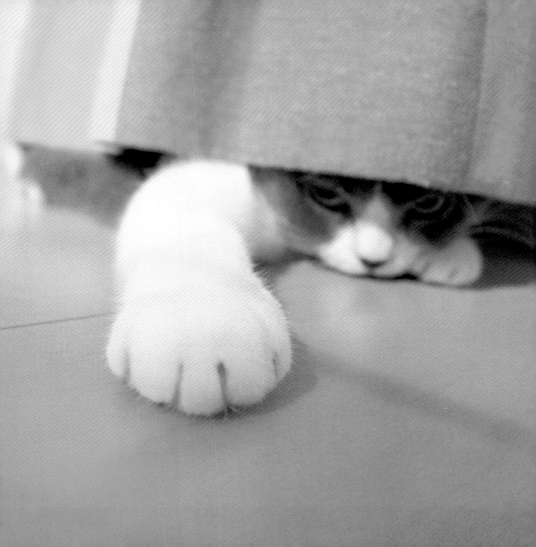

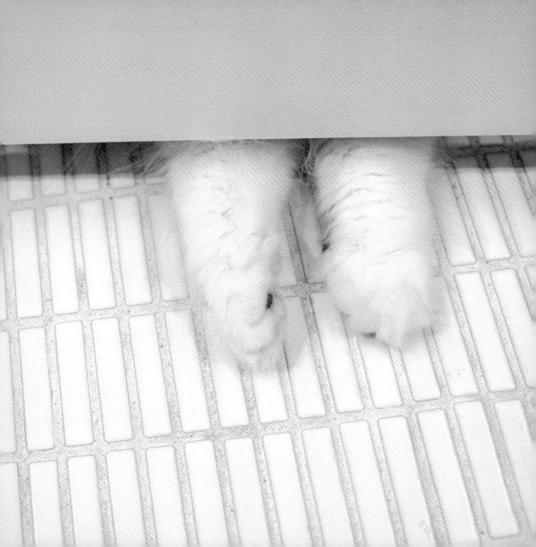

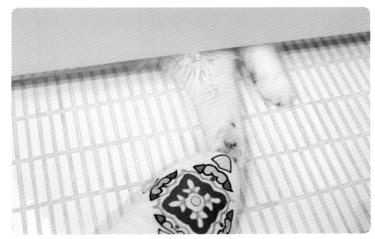

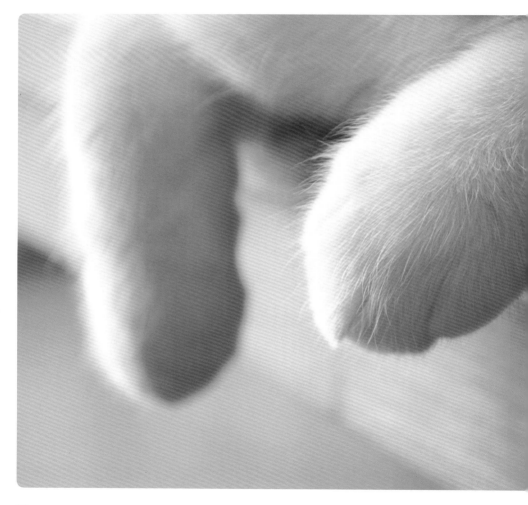

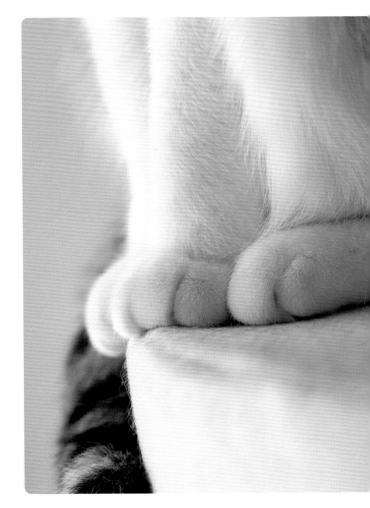

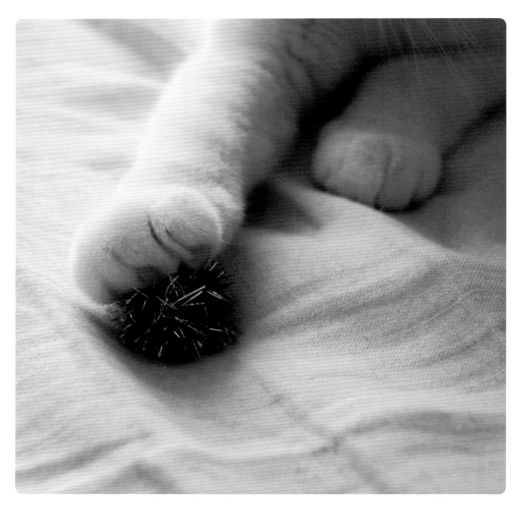

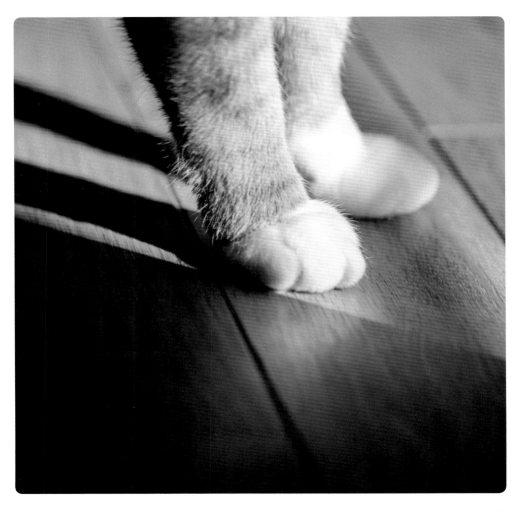

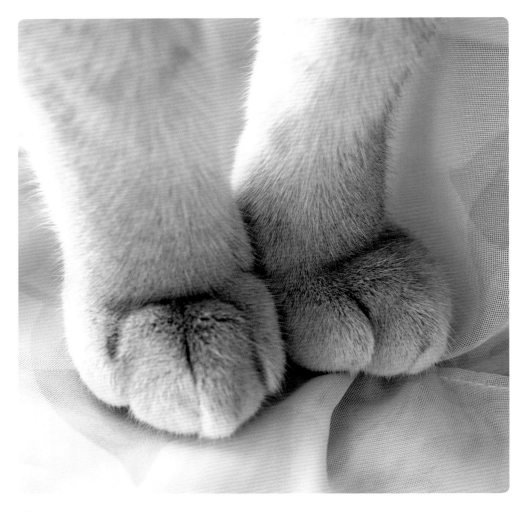

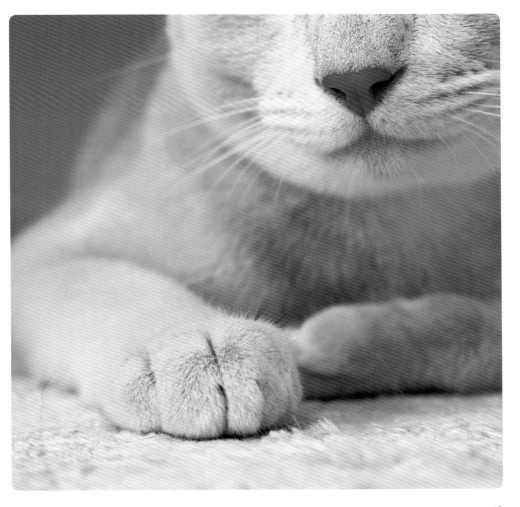

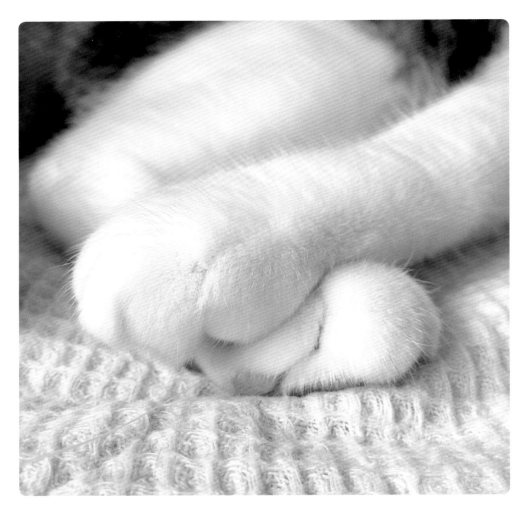

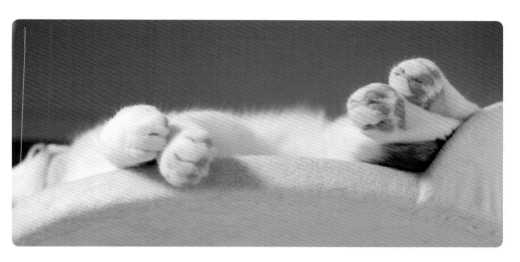

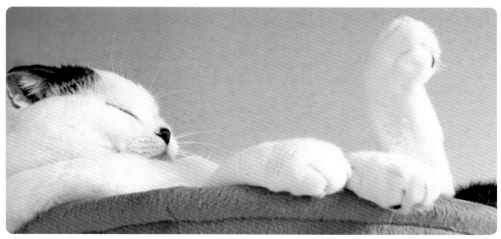

45

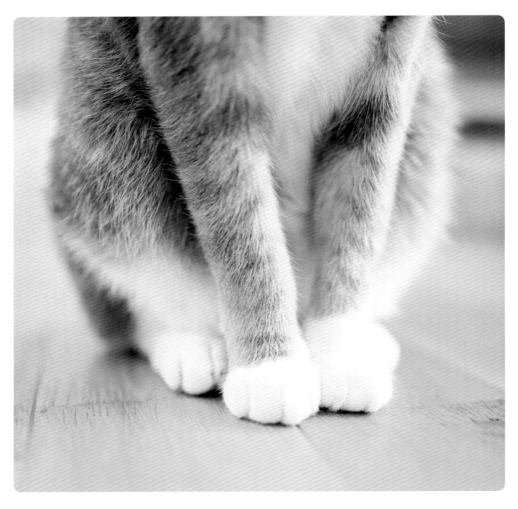

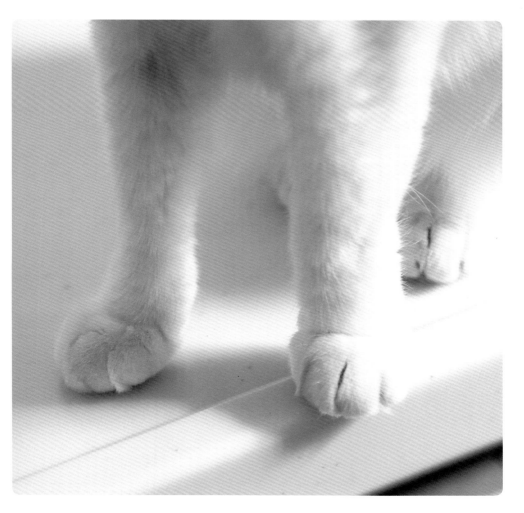

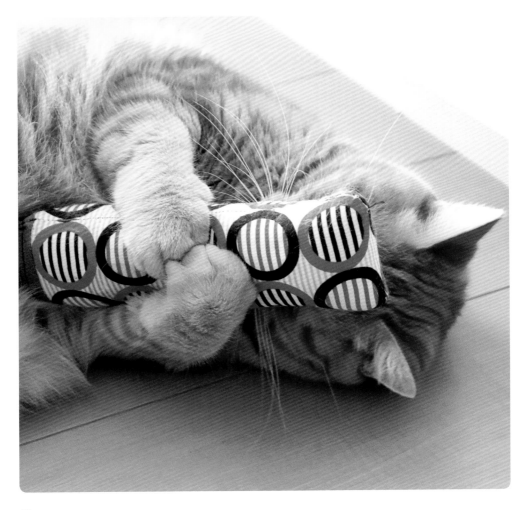

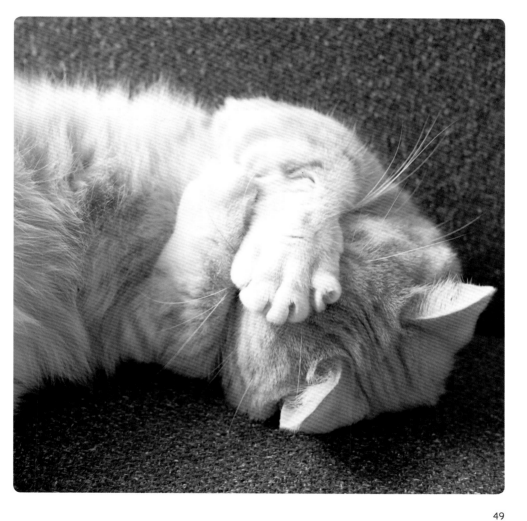

49

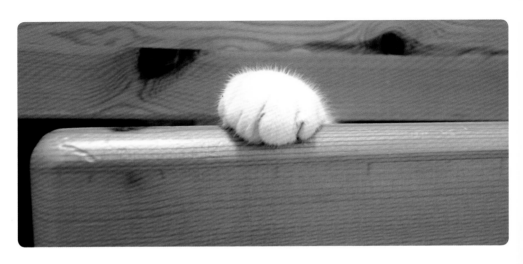

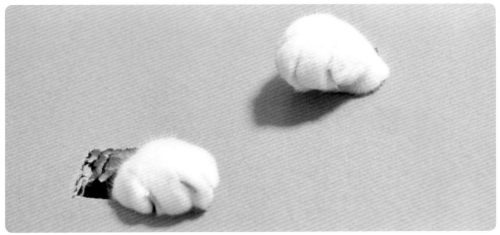

G4 衝撃注

カッター禁止　取扱い注意

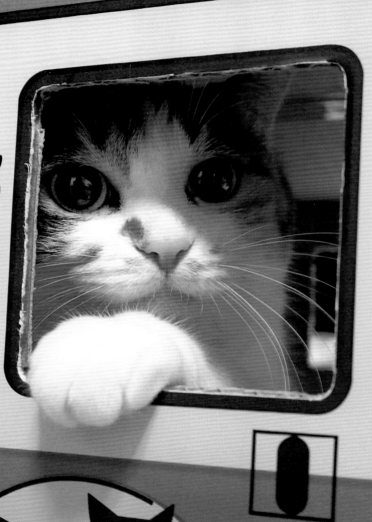

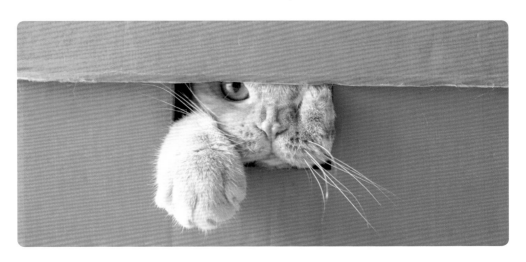

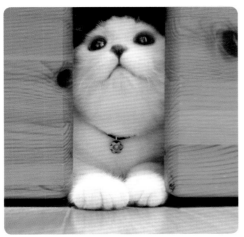

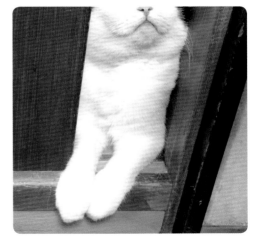

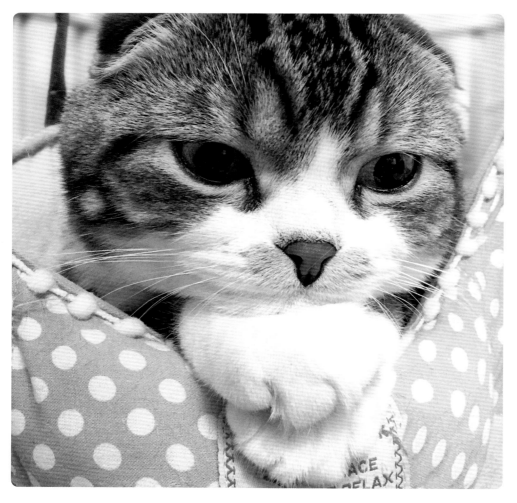

54

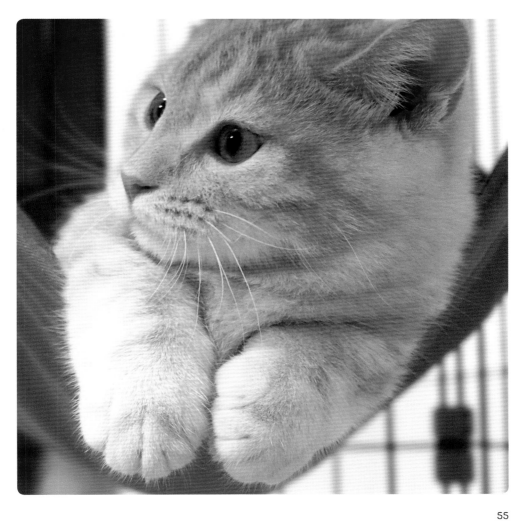

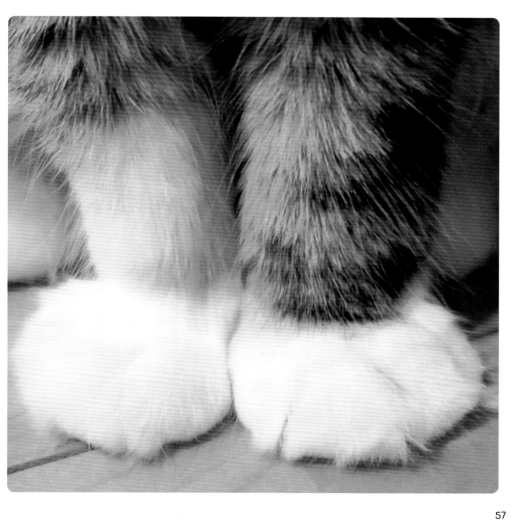

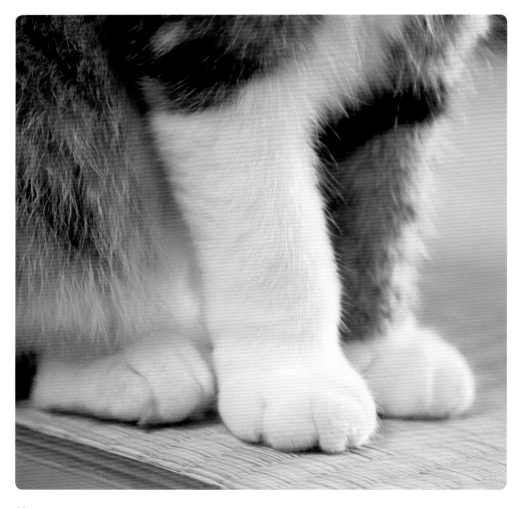

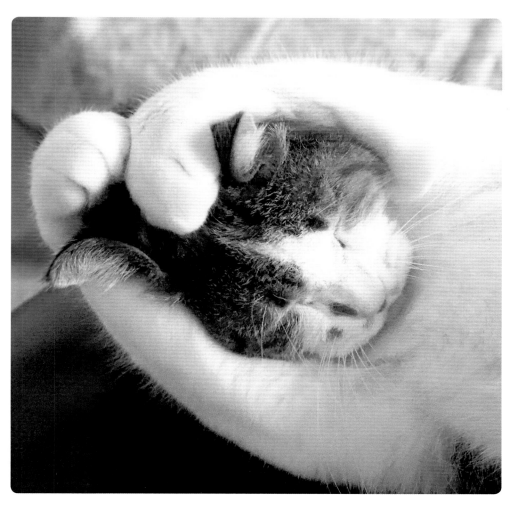

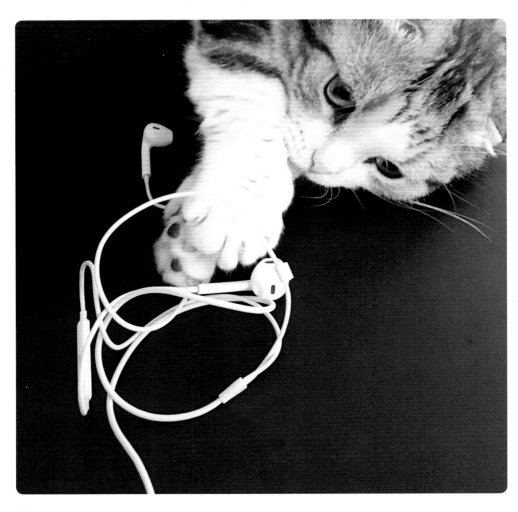

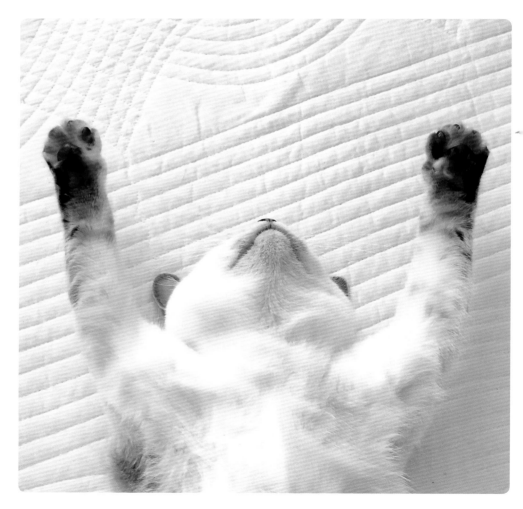

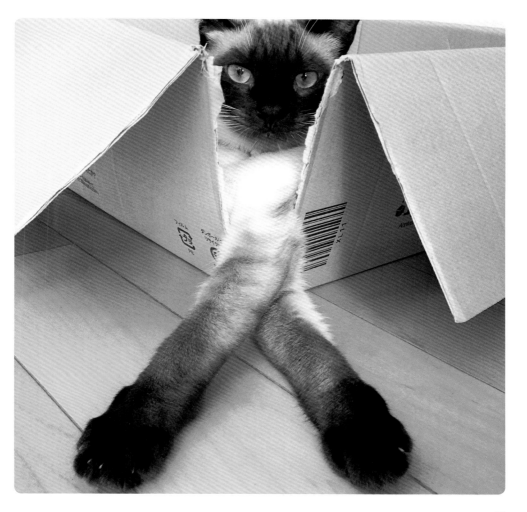

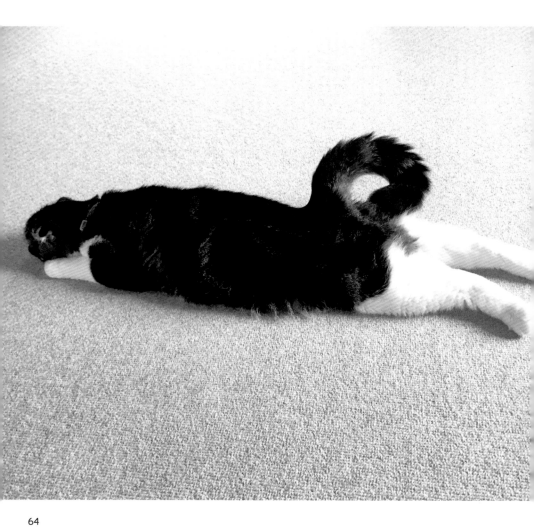

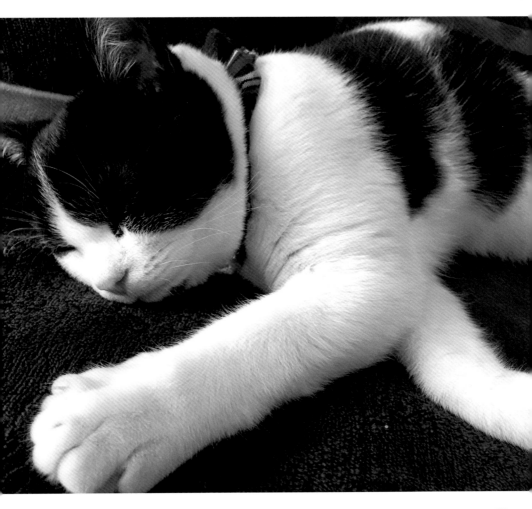

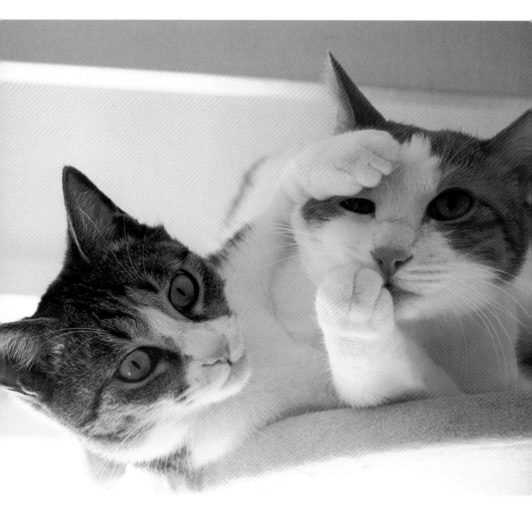

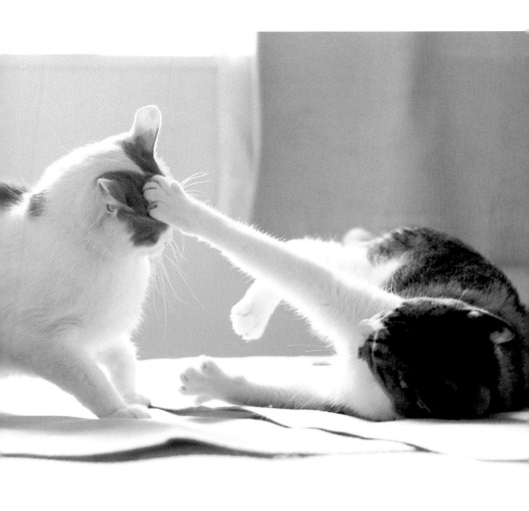

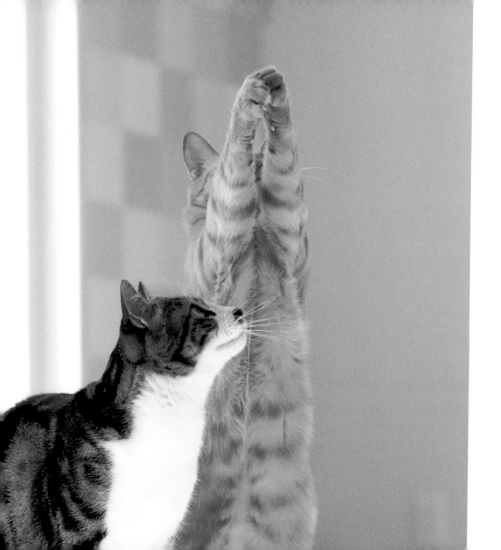

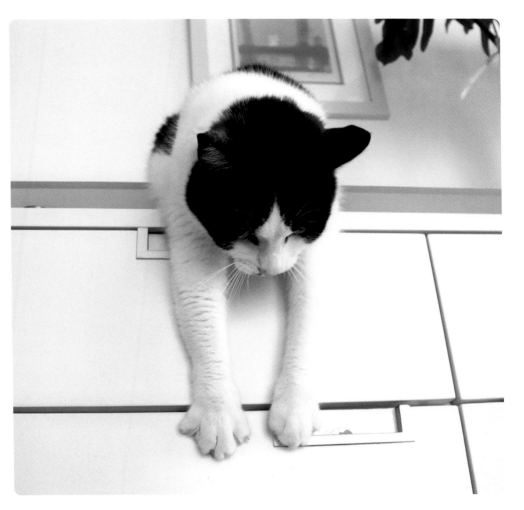

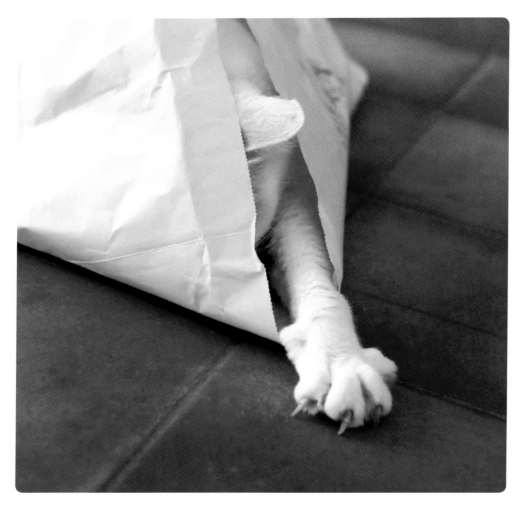

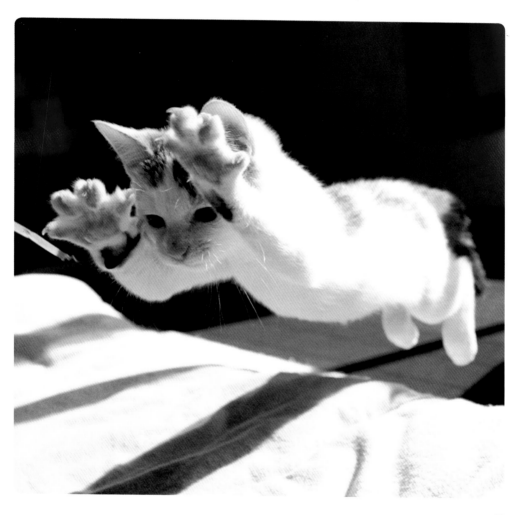

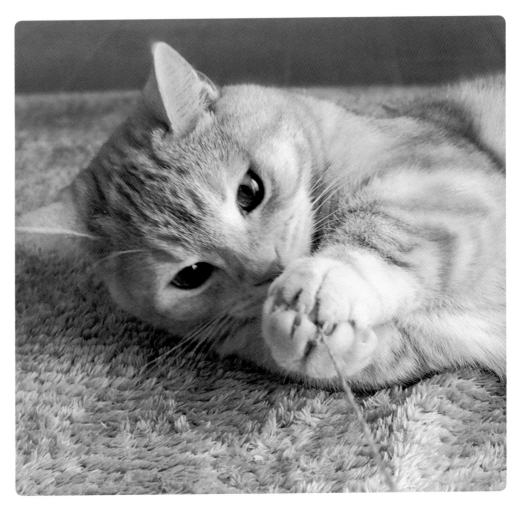

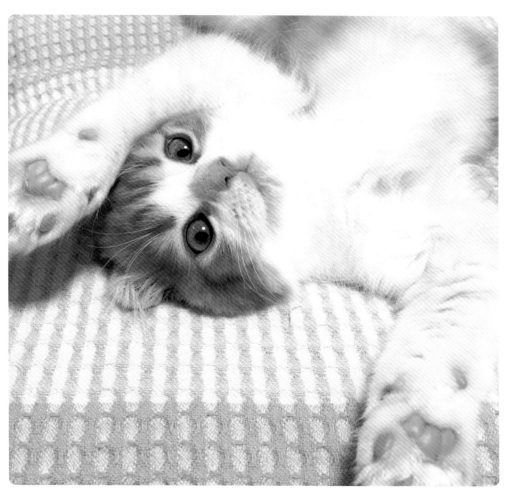

Cat's Paw Trivia ②

Squishy Paw Pads

Paw pads work as the cat's cushion.
Climbing to high places is one of their fortes.
They can jump down without making a noise,
as their paw pads function to cushion the sound.

From time to time you may come across a scene like this: one moment your cat is sitting with you, the very next moment they are out of your sight. Because their squishy paw pads work as a muffling device, they can move around a room silently.

The soft paw pads are essential for the cat's hunting,
helping them remain unnoticed and to creep up on their prey
from behind. The resilient pads allow the cats to be efficient –
beside the fact that they are adorable.

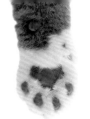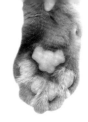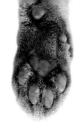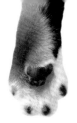

The **Colors** of Cats' Paw Pads

Pink, black, brown or a combination of all of these colors. Just like a cat's hair color shows variation, its paw pads reveal distinctive characteristics. Did you know that the number of pads is different between the front and hind legs? Let's see how different they are and learn the name of each part.

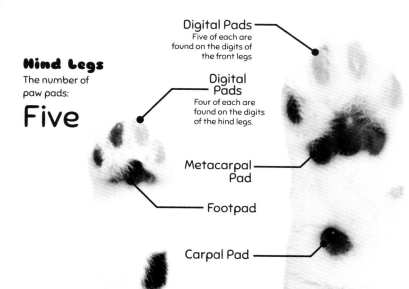

Front Legs
The number of paw pads:

Seven

Hind Legs
The number of paw pads:

Five

Digital Pads
Five of each are found on the digits of the front legs

Digital Pads
Four of each are found on the digits of the hind legs.

Metacarpal Pad

Footpad

Carpal Pad

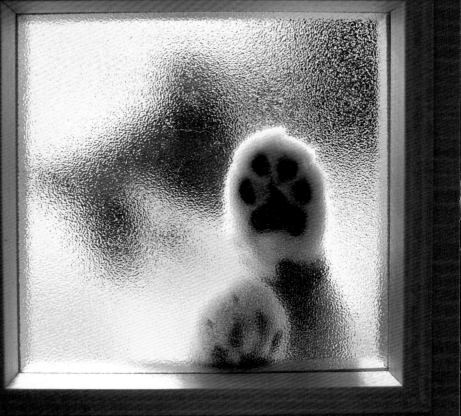

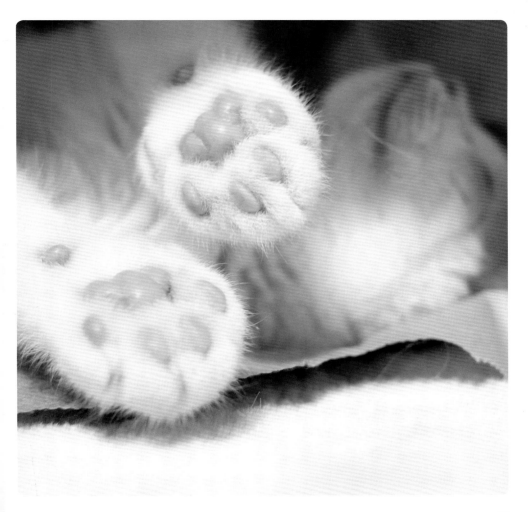

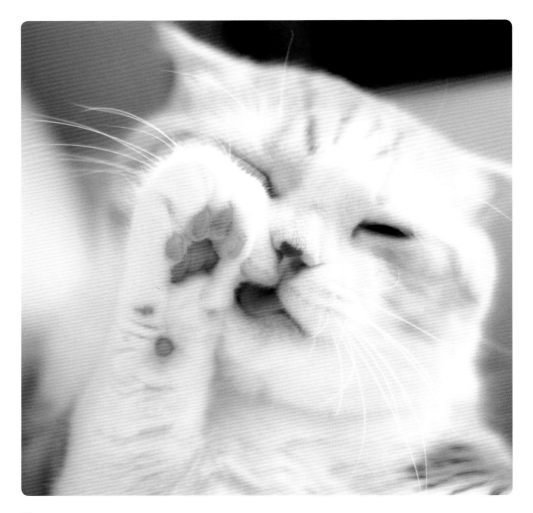

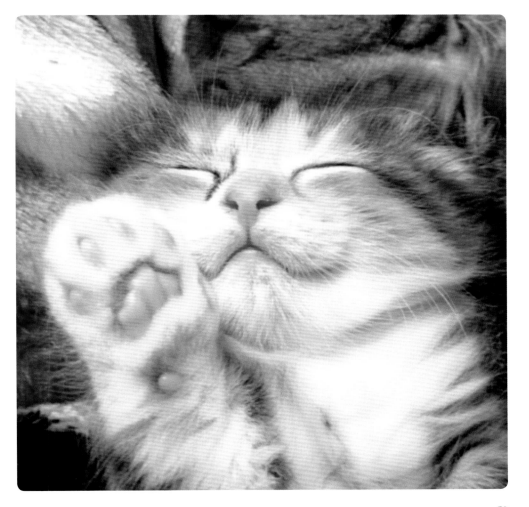

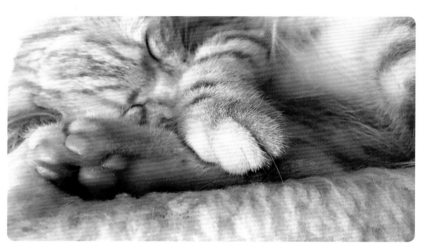

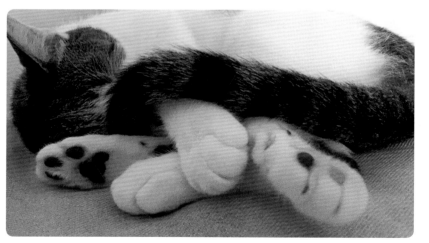

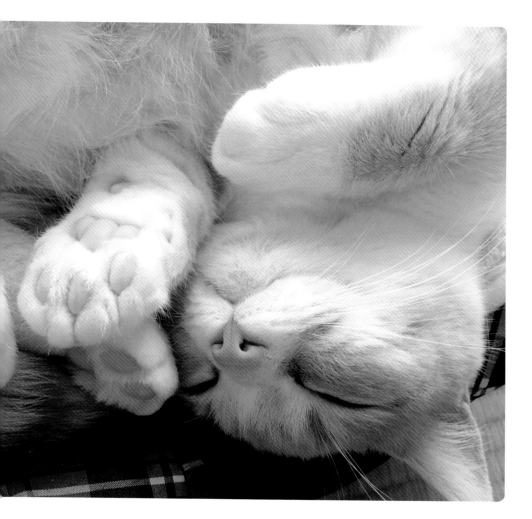

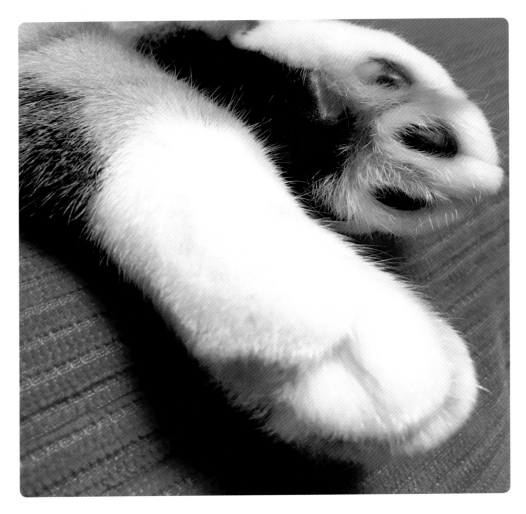

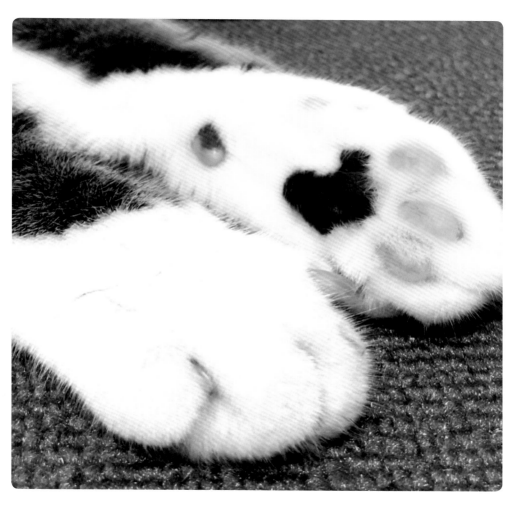

cat profiles ❶

Owner's name
Cat's name

Breed | Sex
🌸 Twitter ID 🌸 Instagram ID 🌸 URL
Appeared in pages...

Kayo
Mugi

Mixed | ♀
🌸 usamaruko0418
front cover and 82

abi2
Kiki

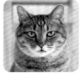

Brown tabby | ♂
🌸 abi12
3, 19, 24

abi2
Coco

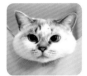

Mixed siamese | ♀
🌸 abi12
22, 62

rojiman
Maru

Scottish fold white | ♂
🌸 rojiman
2, 11, 12

rojiman
Mugi

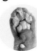
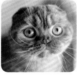

Scottish fold red tabby | ♂
🌸 rojiman
10, 11, 27, 33, 53

rojiman
Nya

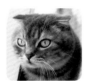

Scottish fold blue tabby | ♂
🌸 rojiman
27

Unamama
Unagi

Scottish fold | ♂
🌸 una1535 🌸 amebro.jp/unagi1535
4, 77

toranyansan
Toragoro

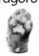

Munchkin | ♂
🌸 toranyansan.blog.fc2.com
5, 25, 48

Makoto
Yuzu

Munchkin | ♂
🌸 yuzuyuzu_nyan_e
6, 7, 14 18, 26, 81

Yuji Kitada
Azuki

British shorthair | ♂
🐾 kitada.yuji 🐾 lineblog.me/kitadayuji
8, 9, 24, 34, 35, 76

Haruu
Mikazuki

Scottish fold | ♀
🐾 mikazukiiiiiii
13, 58

Norihiko & Akiko Suzuki
Mitsuba
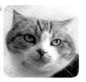
Scottish fold | ♀
🐾 booknori 🐾 umelon_instagram
14

Mugimaru Hopkins
Mugimaru

Scottish fold | ♀
15, 25, 28

jun.k
Donguri
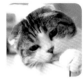
Scottish fold | ♂
🐾 akihimatandon11 🐾 donguri1001
16

tiaichima
Gee Gee
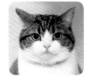
Scottish fold calico | ♂
🐾 tiaichima
19

Natsuki Hamamura
Machiavelli

Munchkin | ♂
🐾 machiavelli_y 🐾 meowonder
19, 32, 36, 37

yayoi
Uzura-chan

Scottish fold | ♂
🐾 yayoi89
20, 21, 28, 54

yayoi
Tara-chan
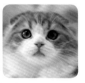
Scottish fold calico | ♂
🐾 yayoi89
73

Maco
Hono

Mixed grey tabby | ♀
🐾 hono.and.bono
23, 41, 46

Umezou Kasan
Raizou

Mixed red tabby white | ♂
🐾 umezouzoo 🐾 umezou.exblog.jp
24, 45, 66, 67

Umezou Kasan
Koume
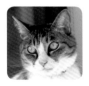
Mixed calico | ♀
🐾 umezouzoo 🐾 umezou.exblog.jp
39, 44, 66, 67

cat profiles ❷

Akuubichan
Coo
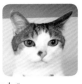
Grey tabby white | ♂
😺 akuubichan
24, 80

Akuubichan
Nell

Mixed siamese | ♂
😺 akuubichan
63

Ryoko Irokawa
Chano

Mixed | ♀
😺 chanoiro
29, 30, 51, 52, 59

Mochimochi's Mama
Ohagi

Mixed Russian blue | ♂
😺 yomokinakohagi 😺 mochi_ryoko
29, 42

Mochimochi's Mama
Kinako
Mixed Russian blue | ♂
😺 yomokinakohagi 😺 mochi_ryoko
29, 43

Marble
Vani
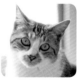
Grey tabby | ♂
😺 marble820
31

Marble
Don Don
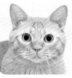
Mixed red tabby | ♂
😺 marble820
68

Marble
Poola
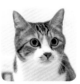
Brown tabby | ♂
😺 marble820
68

Pochi_mal
Ten Ten

Grey tabby white | ♂
😺 pochi_mal
29, 71

Mari
Inaho

Scottish fold | ♂
😺 inaho_cat
38, 40, 45, 50, 53, 74

emi
Pooh

Munchkin | ♂
😺 pooh_0403 😺 pooh0403
49, 55, 72

kozu*
Moco

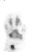
Mixed white | ♀
🐾 kozukozu.0510
47, 70

kozu*
Nyanta

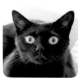
Mixed black | ♀
🐾 kozukozu.0510
61

kozu*
Chibiko

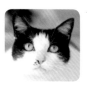
Mixed black & white | ♀
🐾 kozukozu.0510
69

Shimizu
Nori

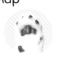
Scottish fold | ♂
53

aja.ri
Mikan

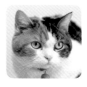
Munchkin | ♀
🐾 aja.ri
56

yoko
Melon

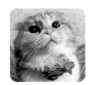
Mixed | ♀
🐾 yoko_1011
57, 79

mapuko & mapuo
Map
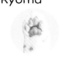
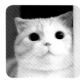
Munchkin | ♂
🐾🐾 map_u_chin
60

Aya
Fuku

Scottish fold | ♂
🐾 fukufukufukusuke
64

TOMOKO
RICK

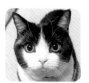
British shorthair | ♂
🐾 asanoram
65

Koneko
Ryoma

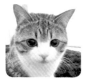
Scottish fold | ♂
🐾 rieneko555 🐾 loveneko812.blog.fc2.com
78

Mofuta Mama
Mofutaro

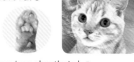
American shorthair | ♂
🐾 mofuta_nyan
80

chika
Suzume
Mixed | ♂
🐾 suzume0513
83

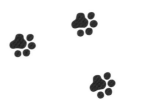

CAT PAWS

Editor Yuka Tsutsui (PIE International)
Art direction Daisuke Matsumura (PIE Graphics)

Translator Rico Komanoya
Copyeditor Andrew Pothecary (itsumo music)
Typesetting and cover design Andrew Pothecary (itsumo music)
Production Aki Ueda (Pont Cerise)

Originally published in Japanese in 2017 by PIE International Inc.
English edition: first published in 2018 by PIE International Inc.

PIE International Inc.
2-32-4 Minami-Otsuka, Toshima-ku, Tokyo 170-0005 JAPAN
international@pie.co.jp
www.pie.co.jp/english

ISBN: 978-4-7562-5081-0

Third printing in February 2023
Printed in China